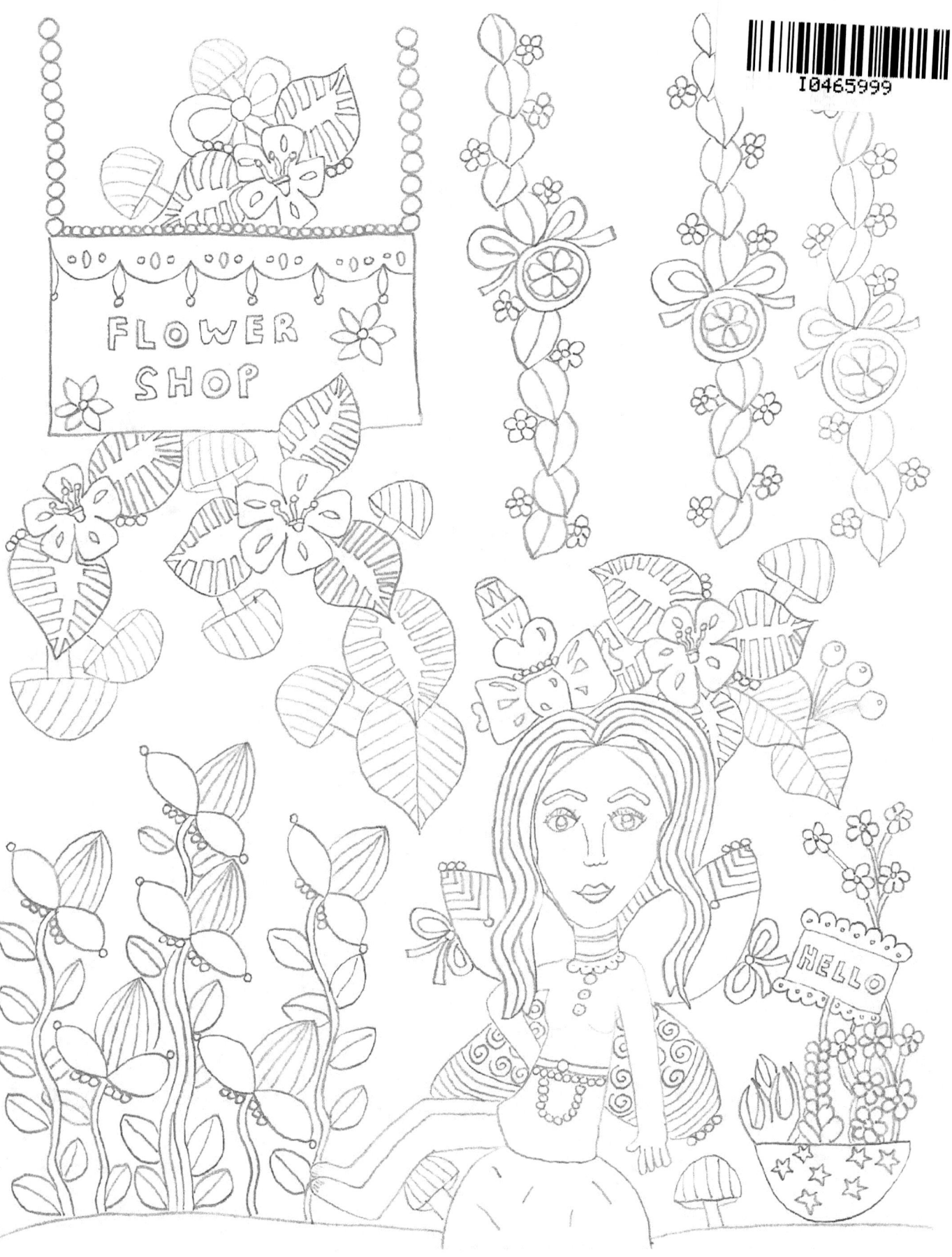

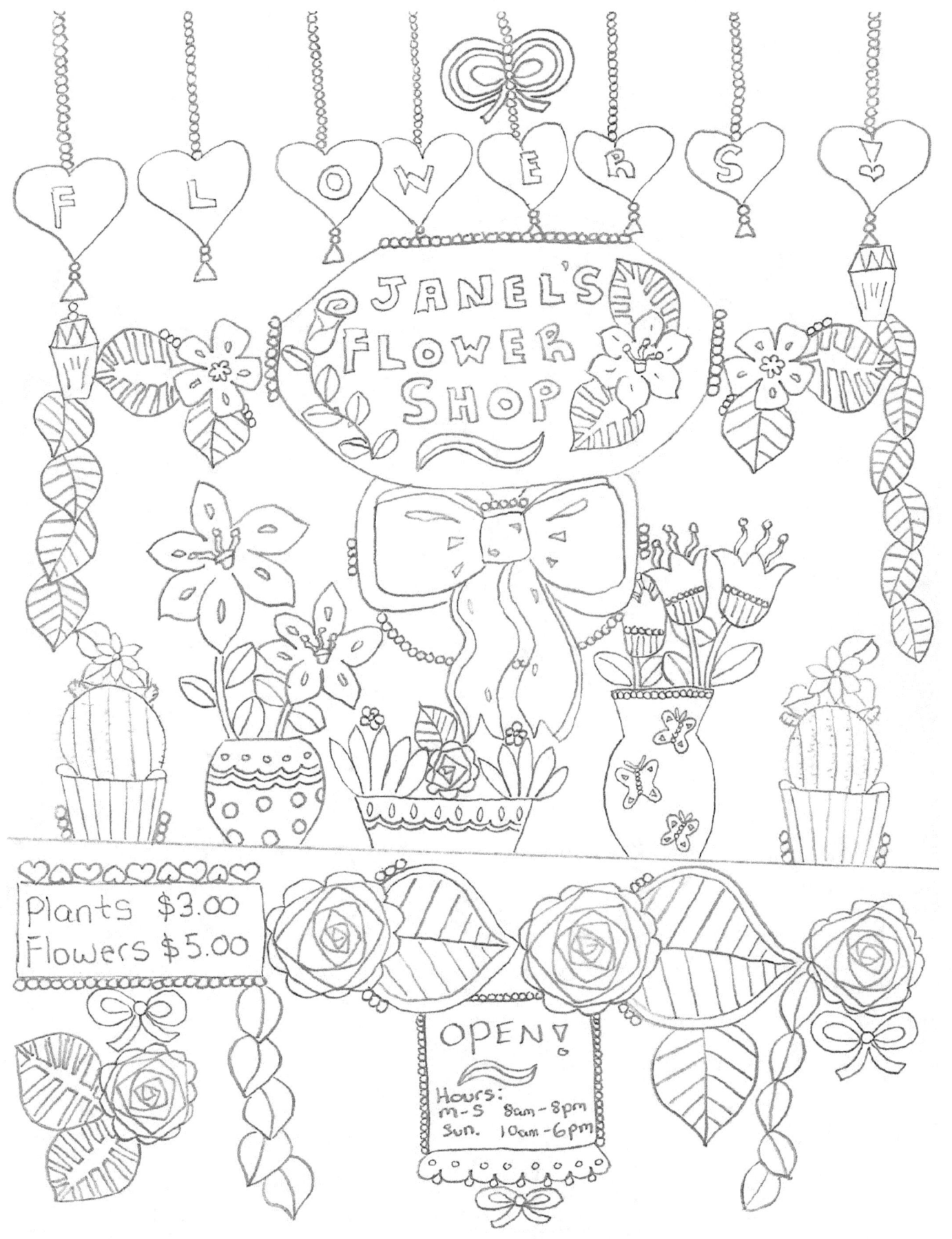

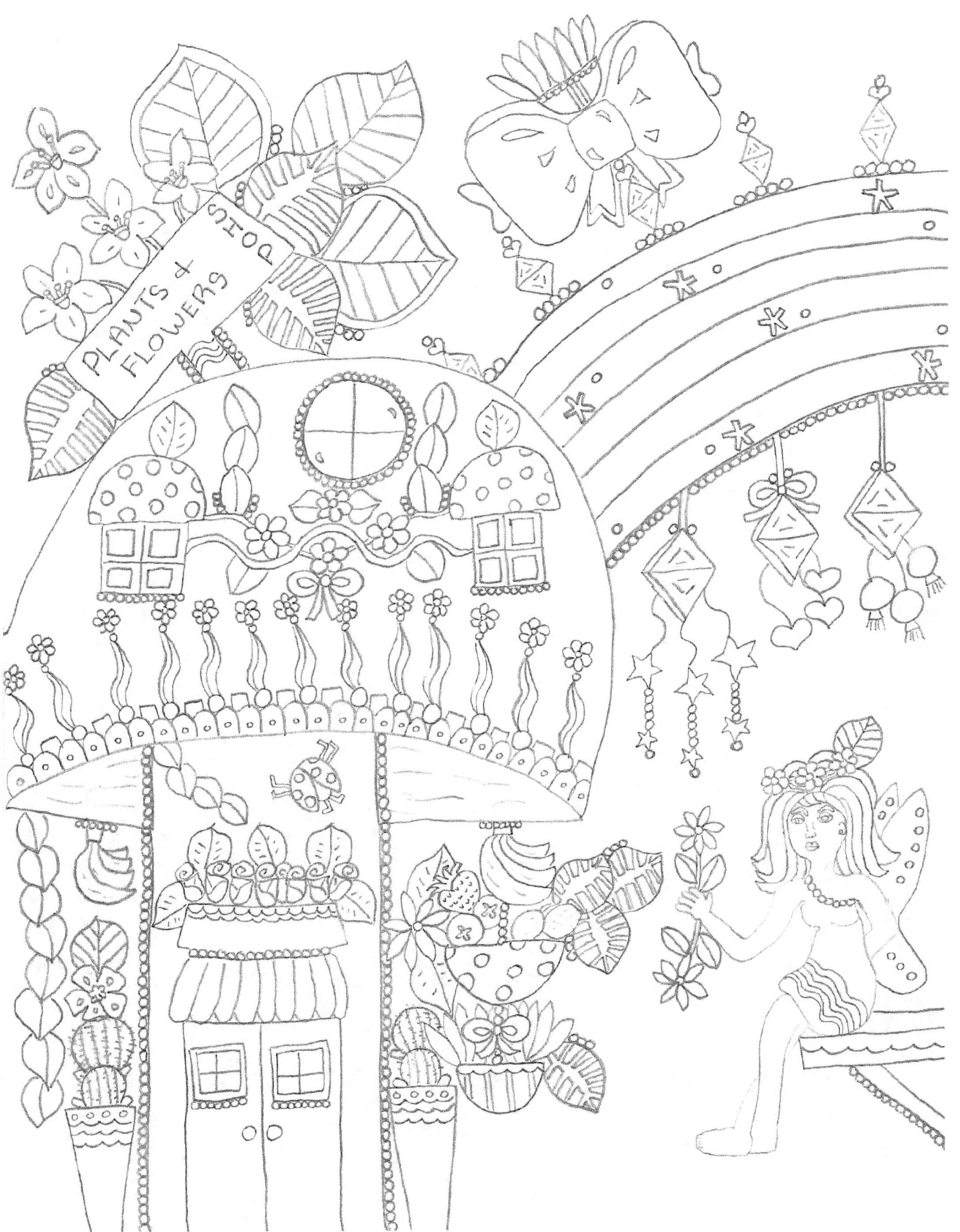

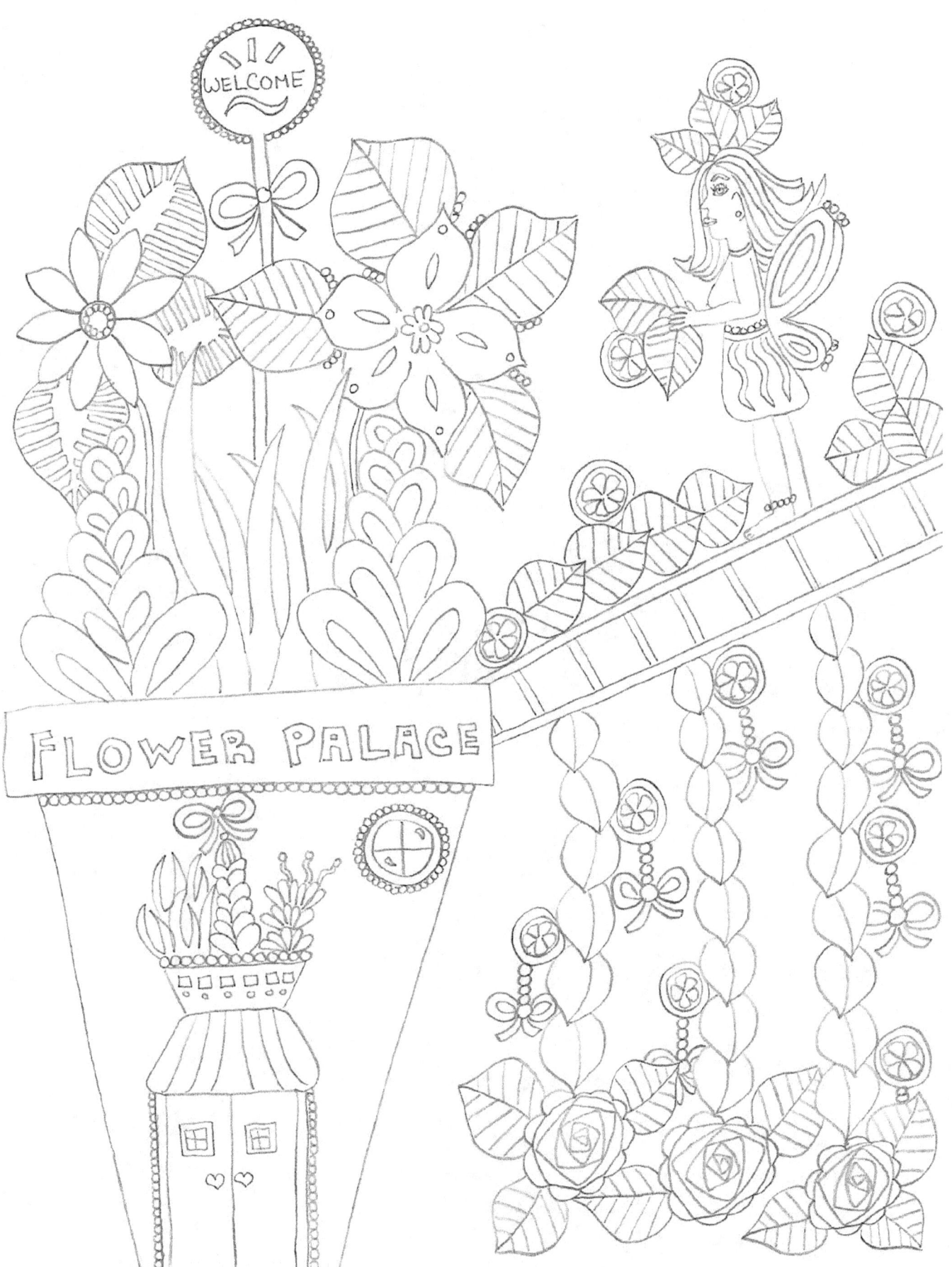

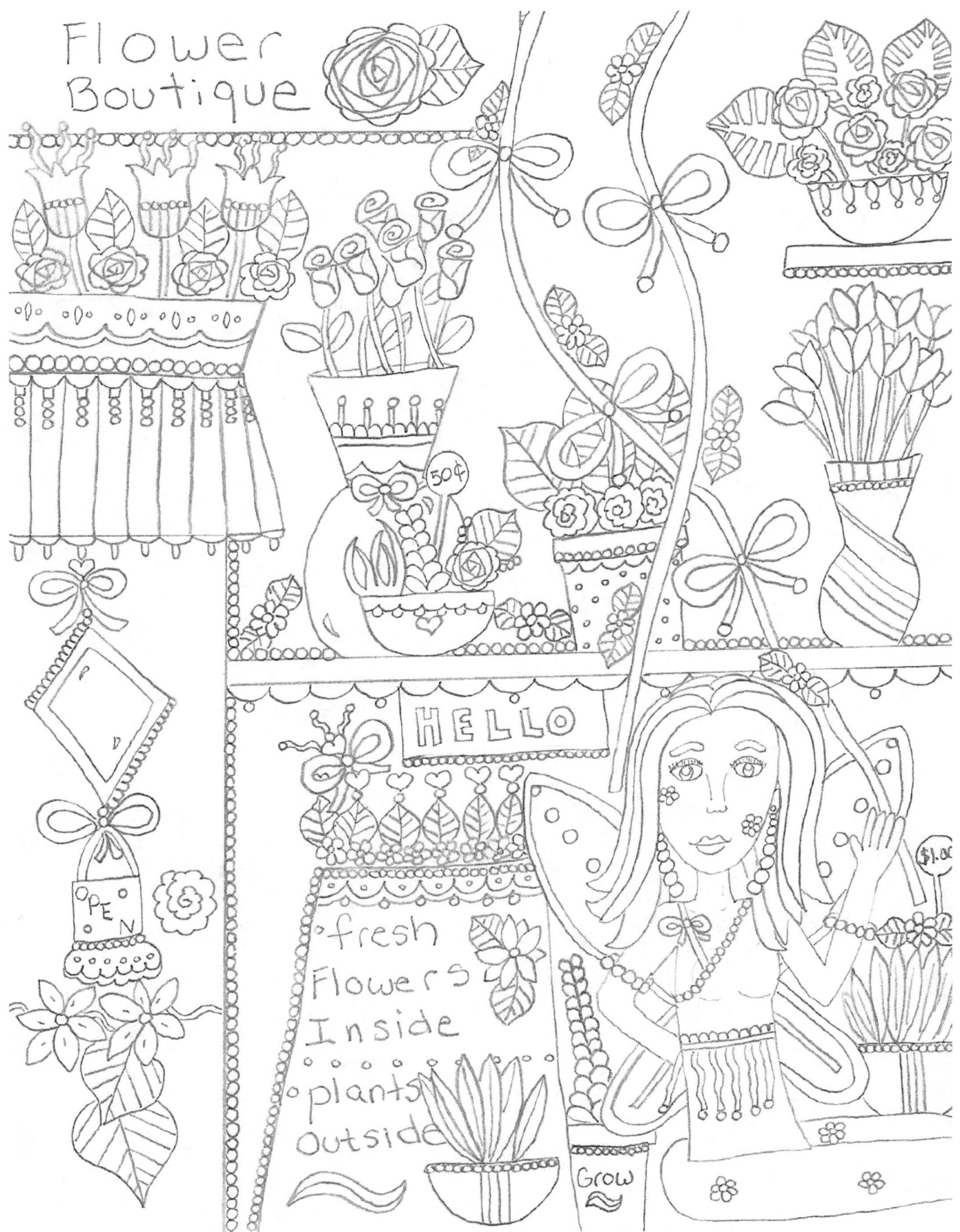

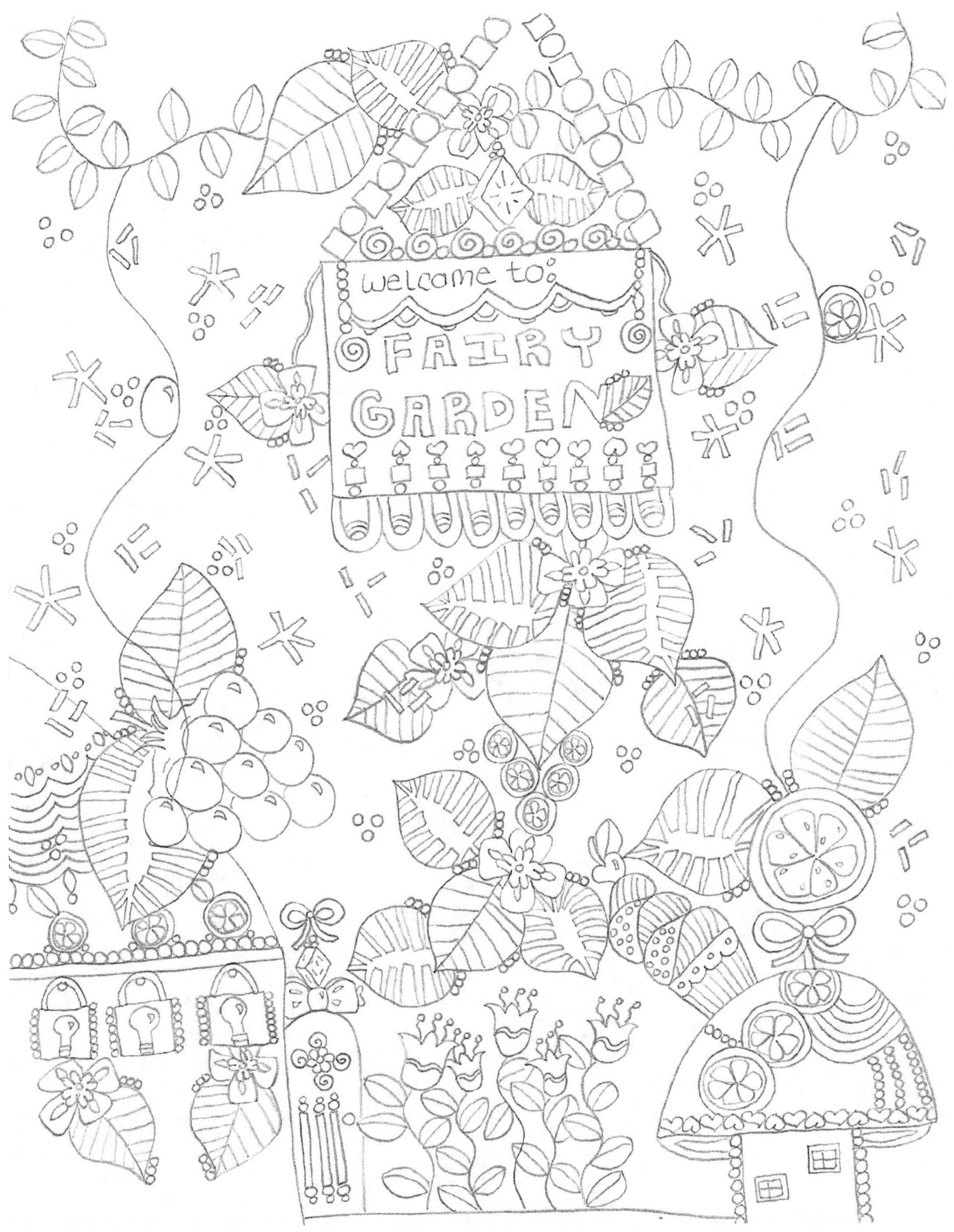

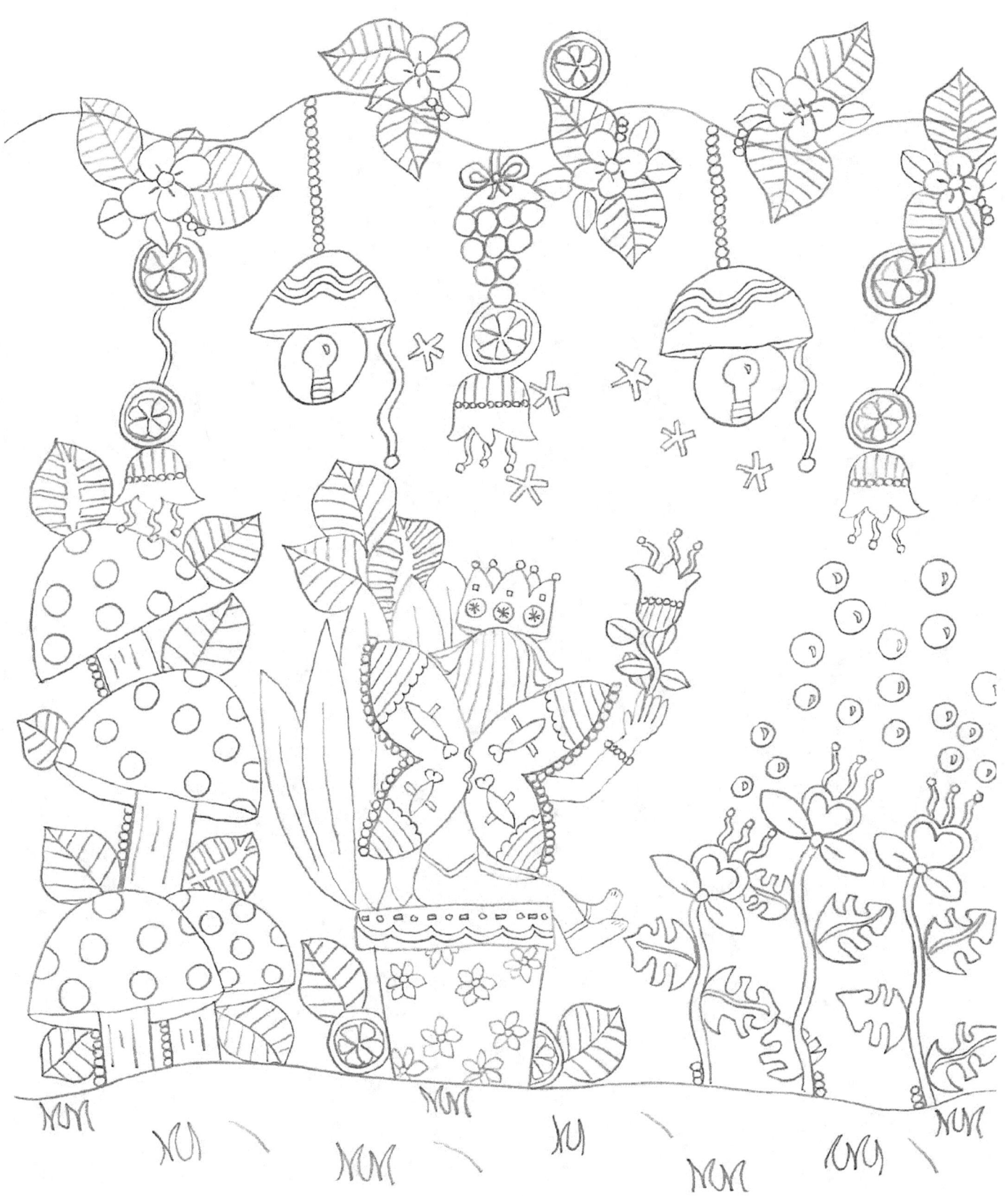

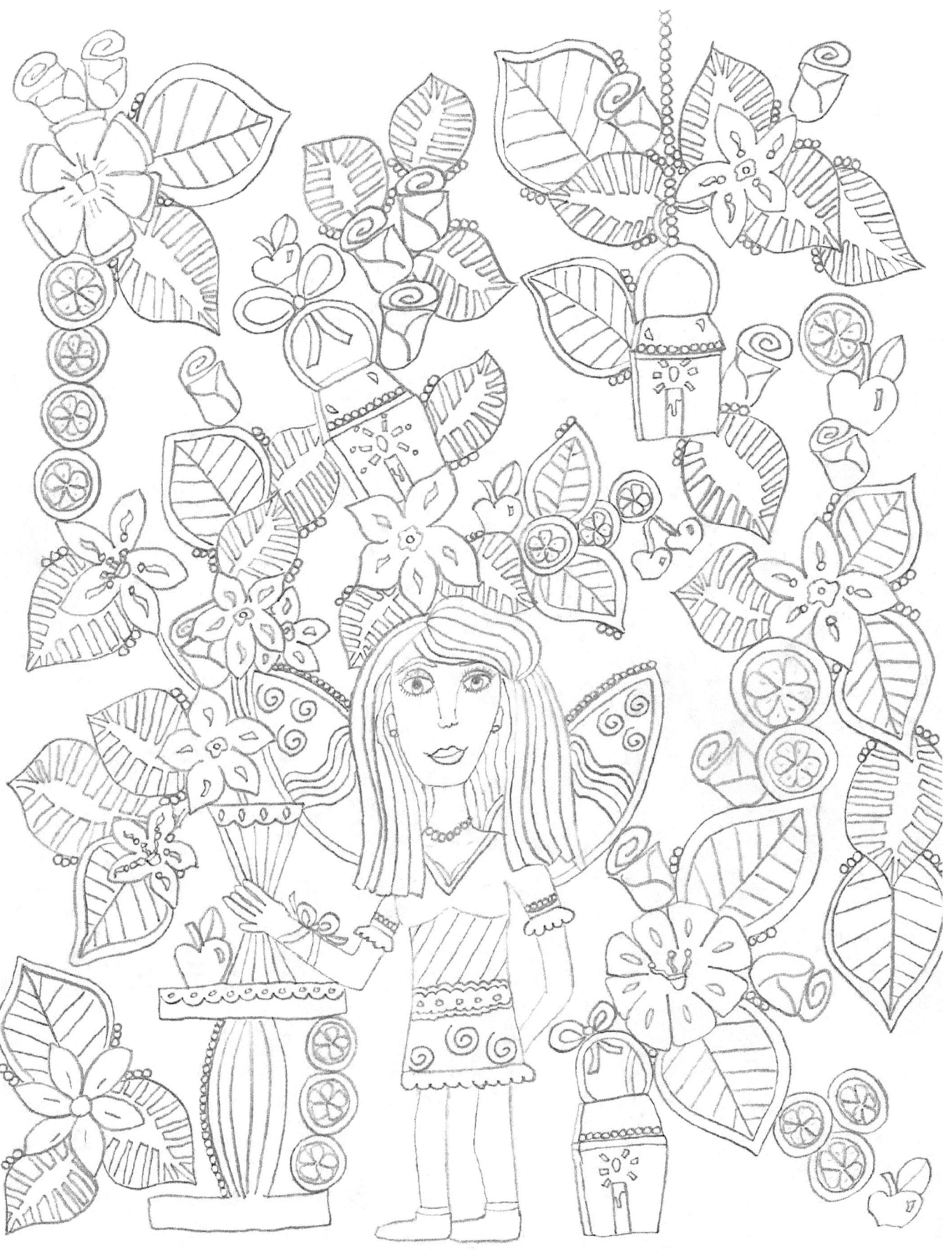

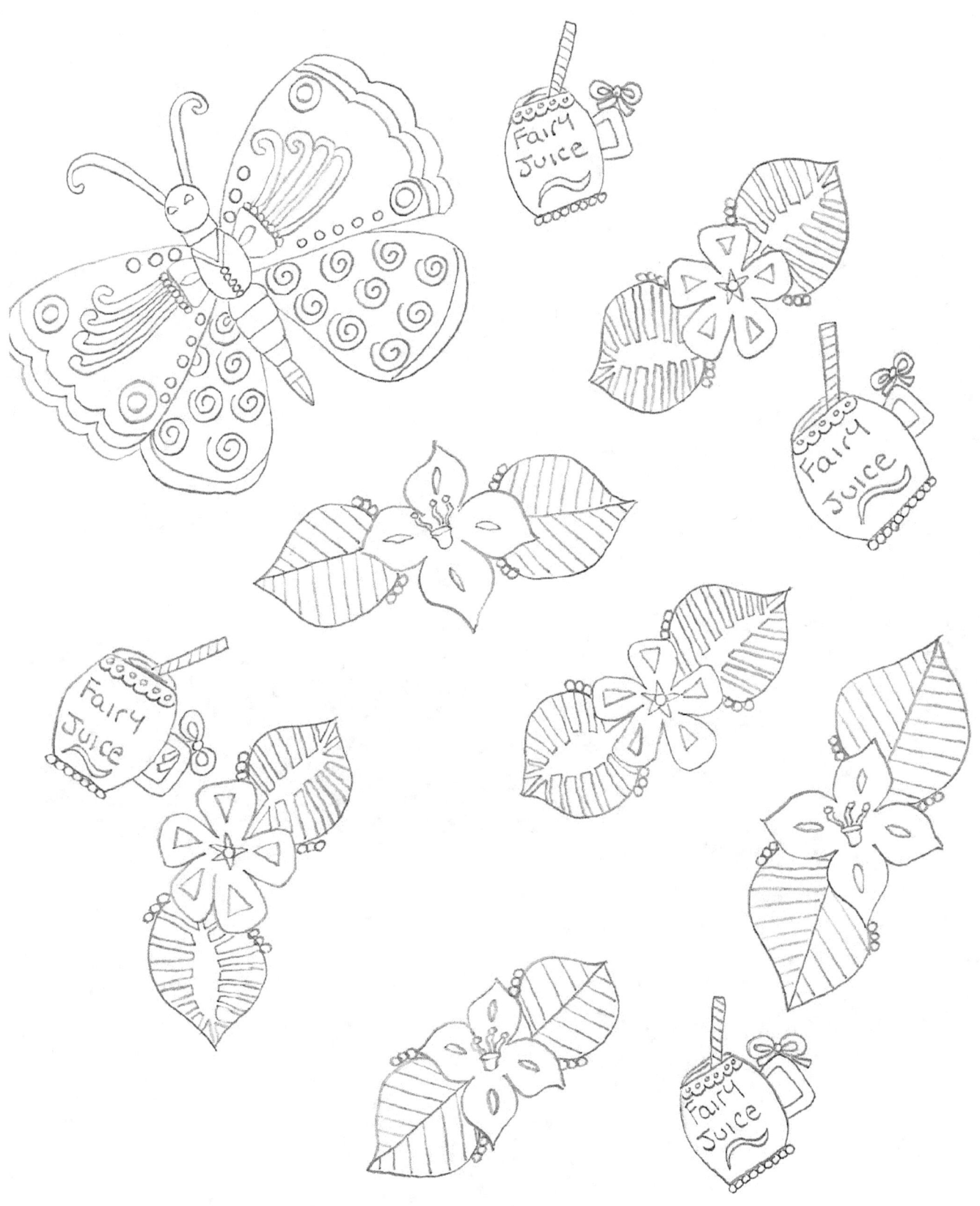

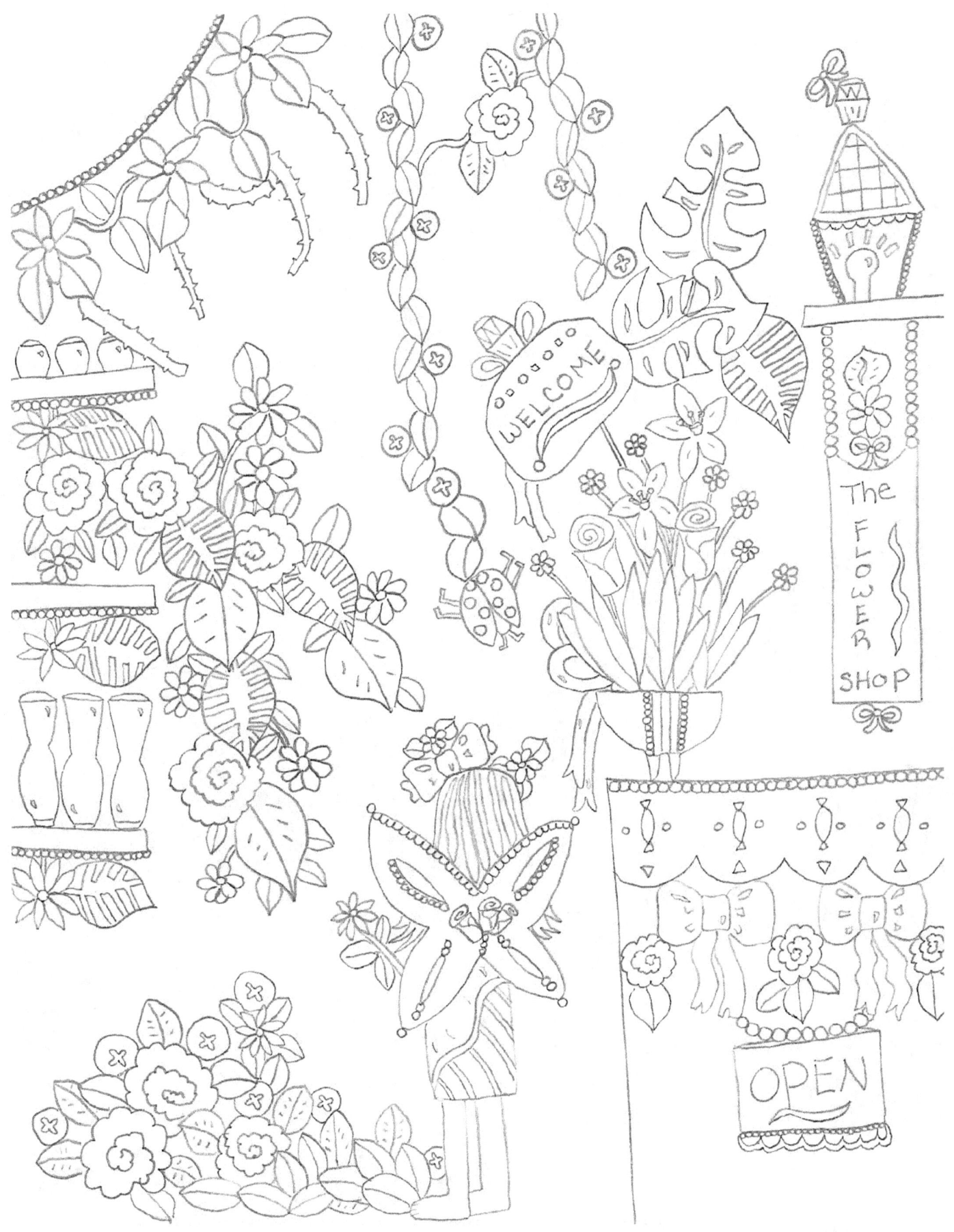

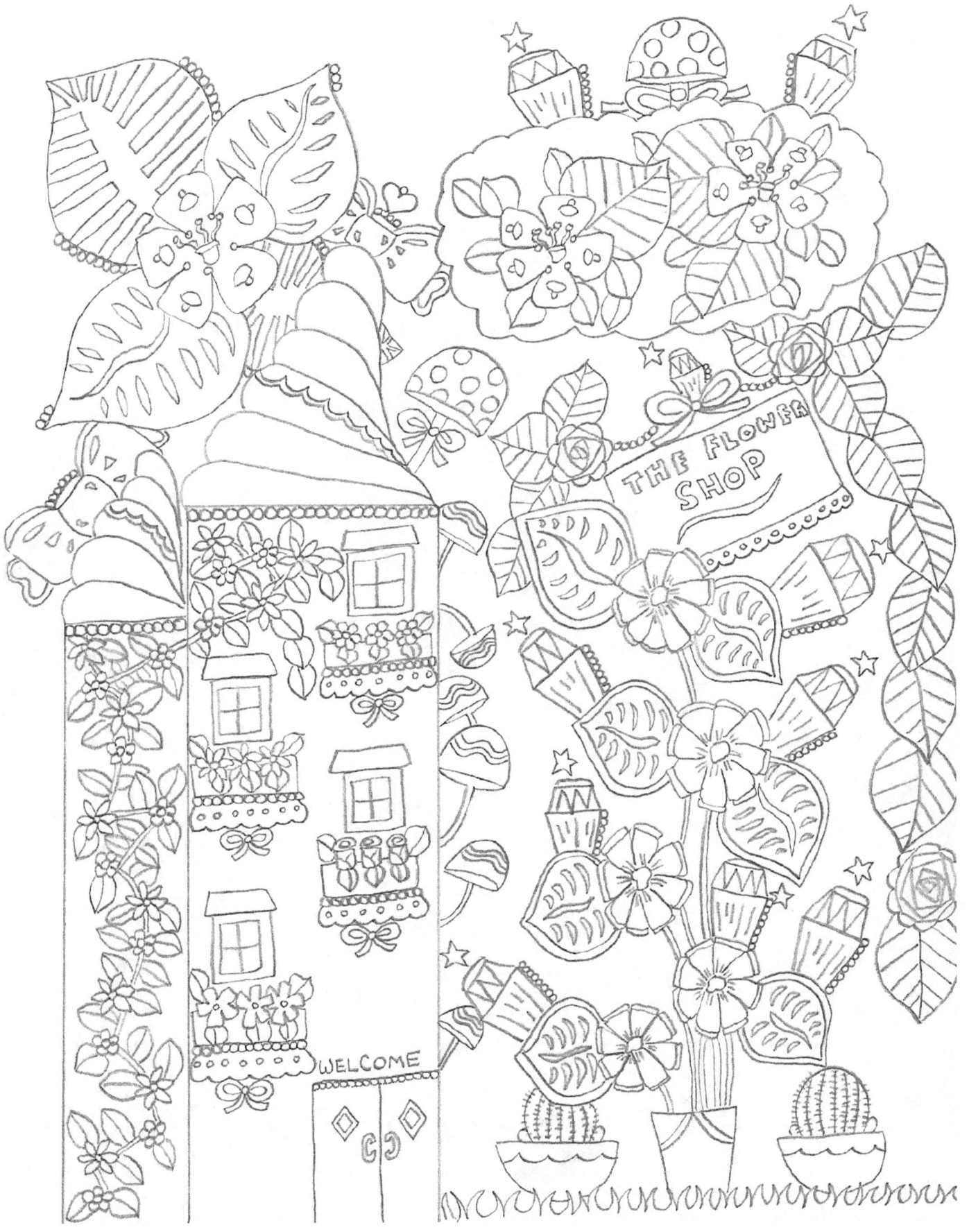

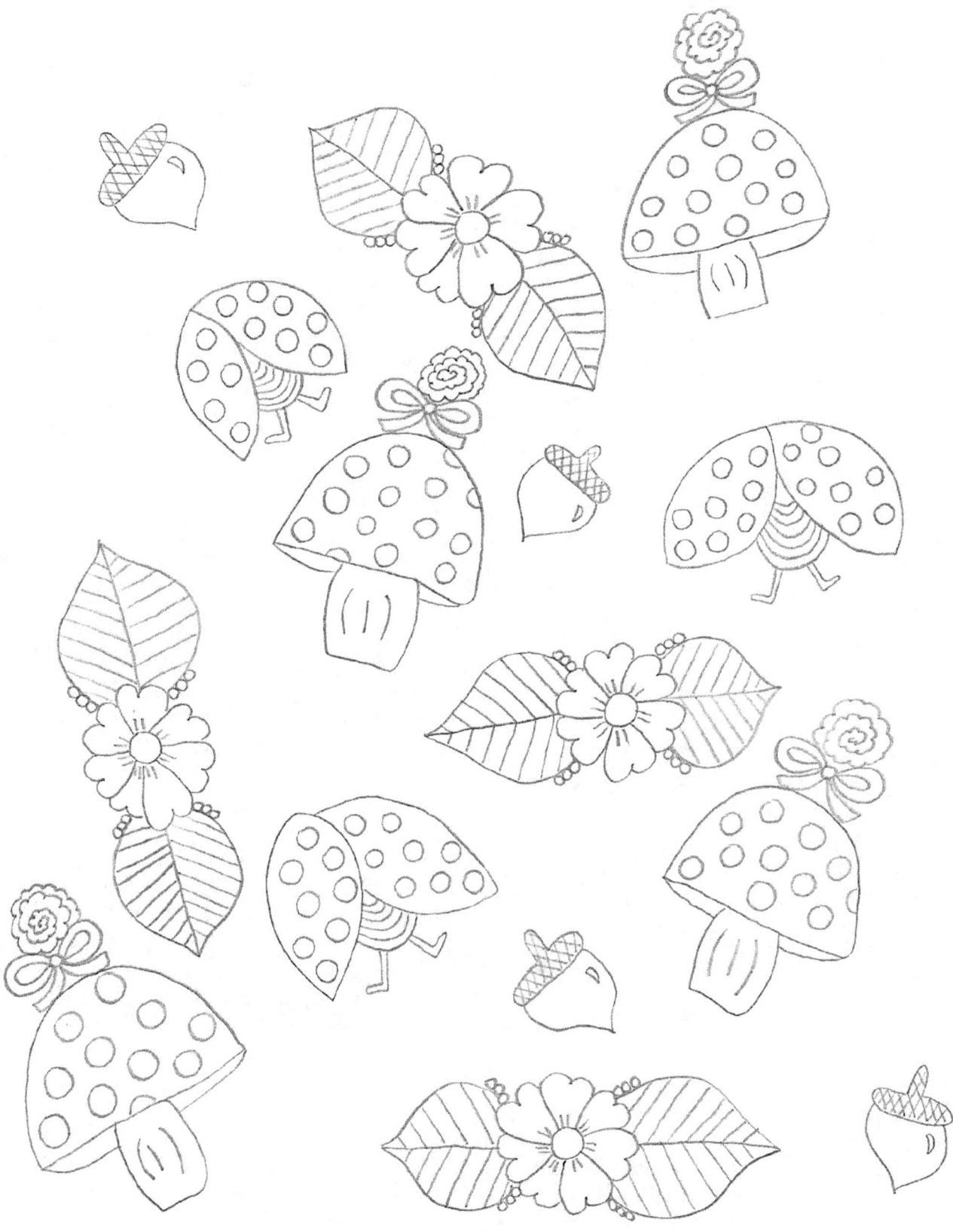

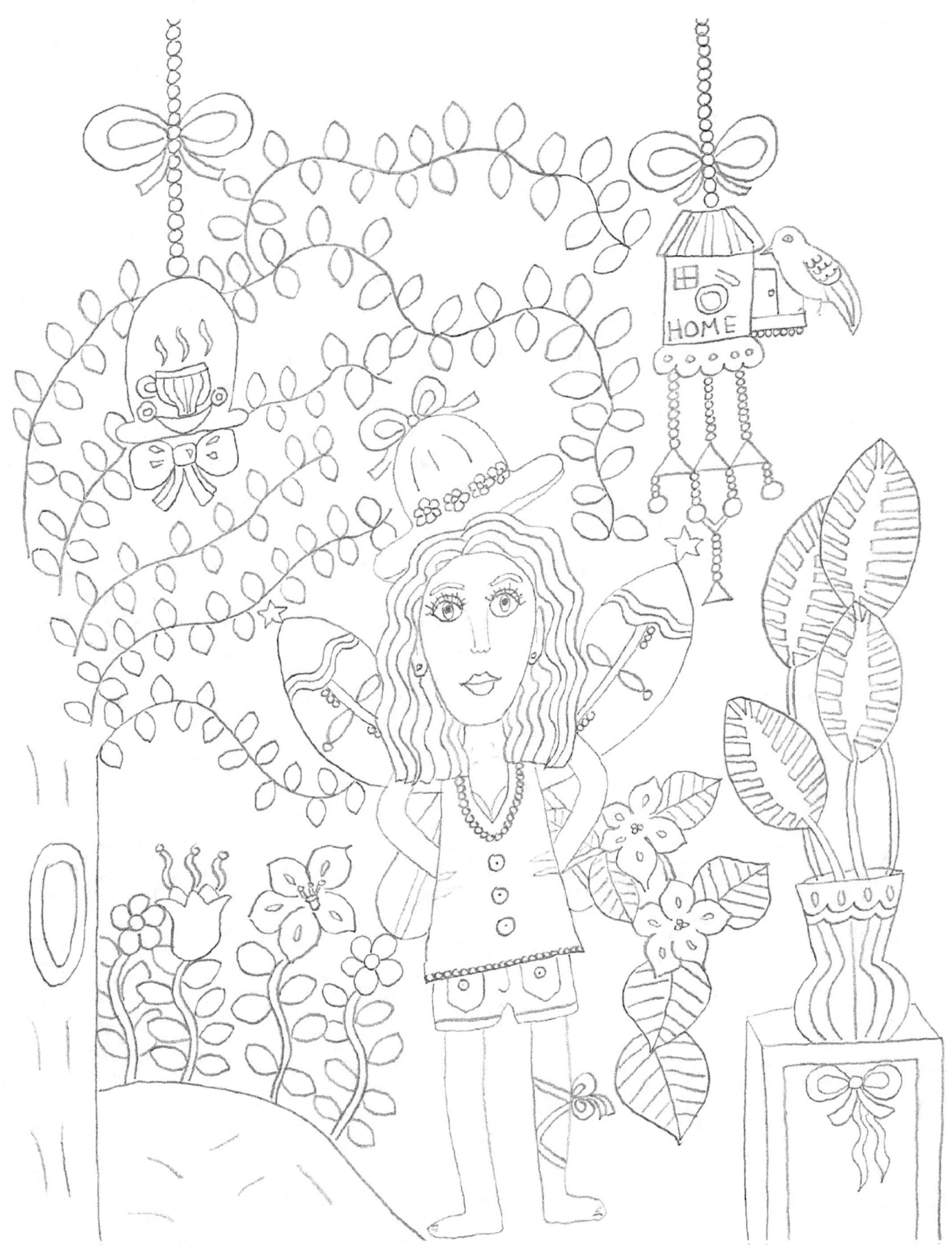

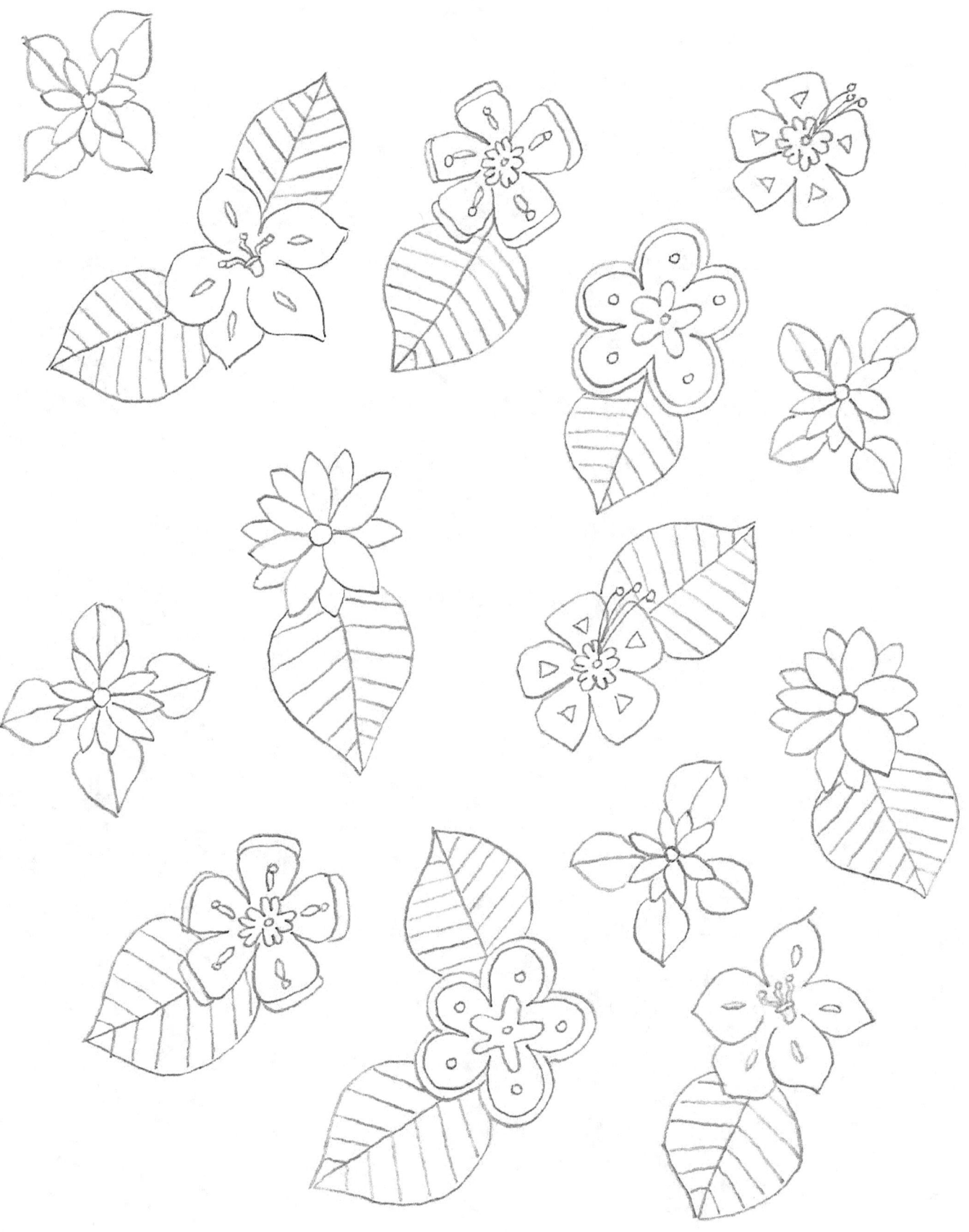

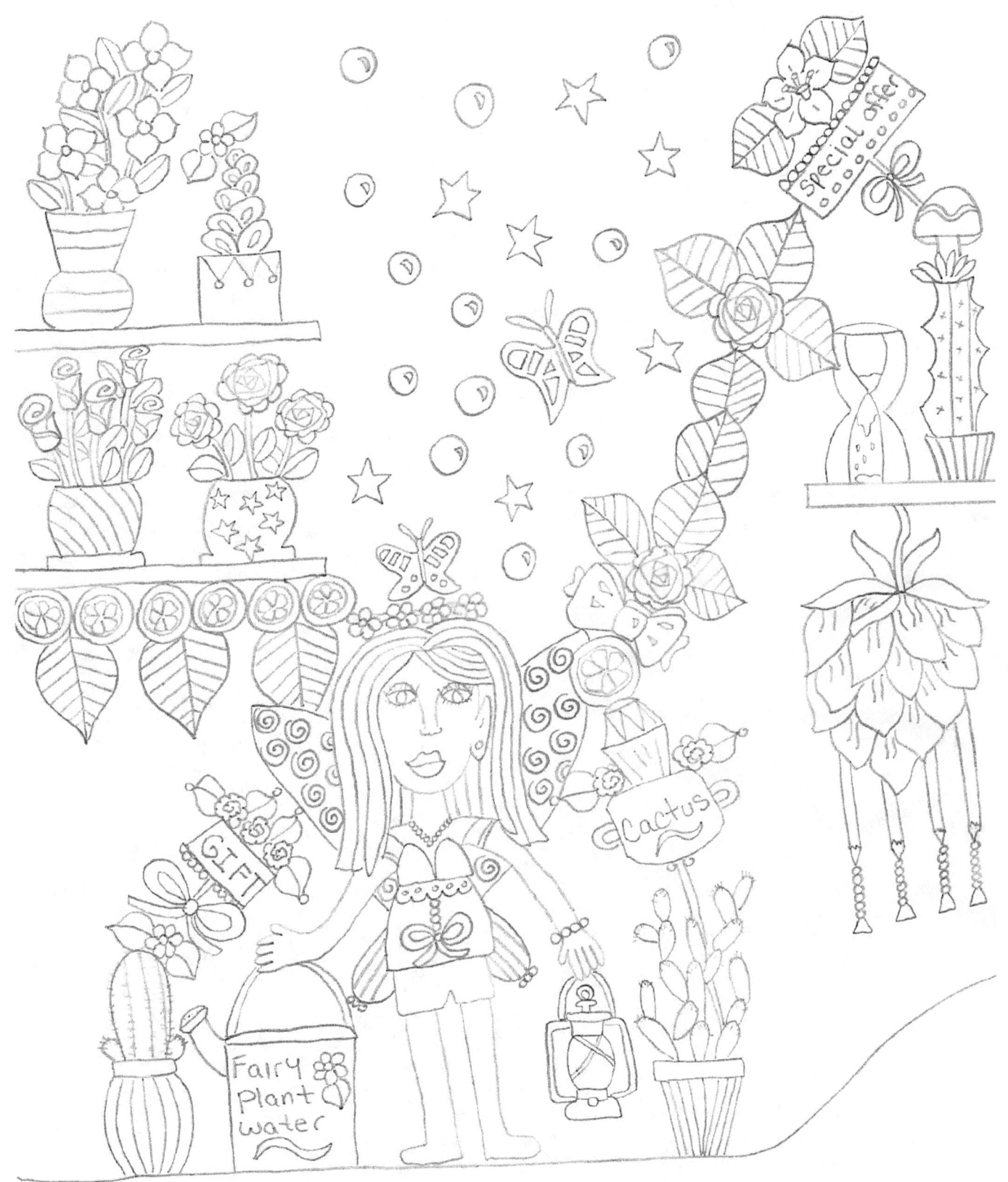

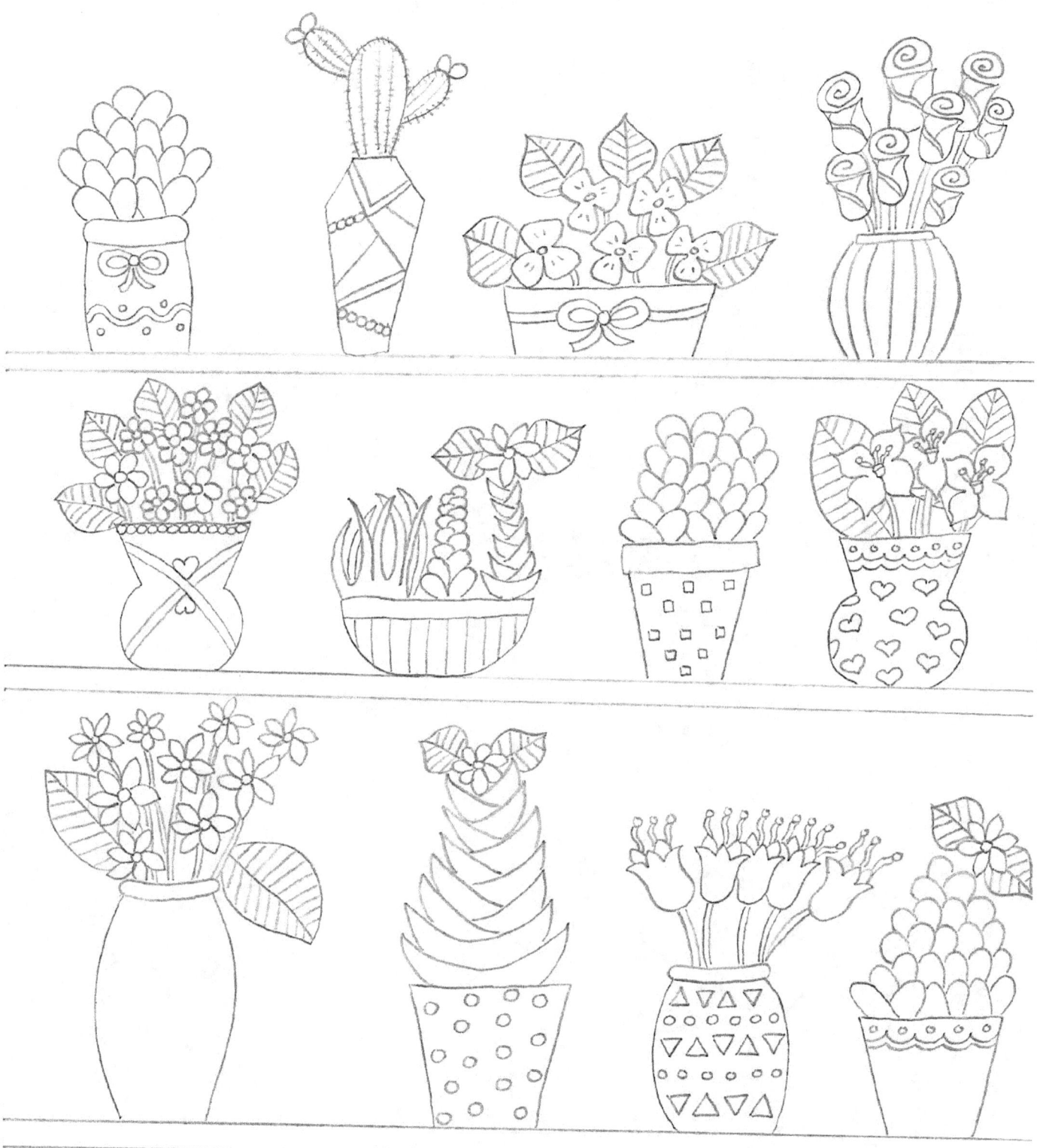

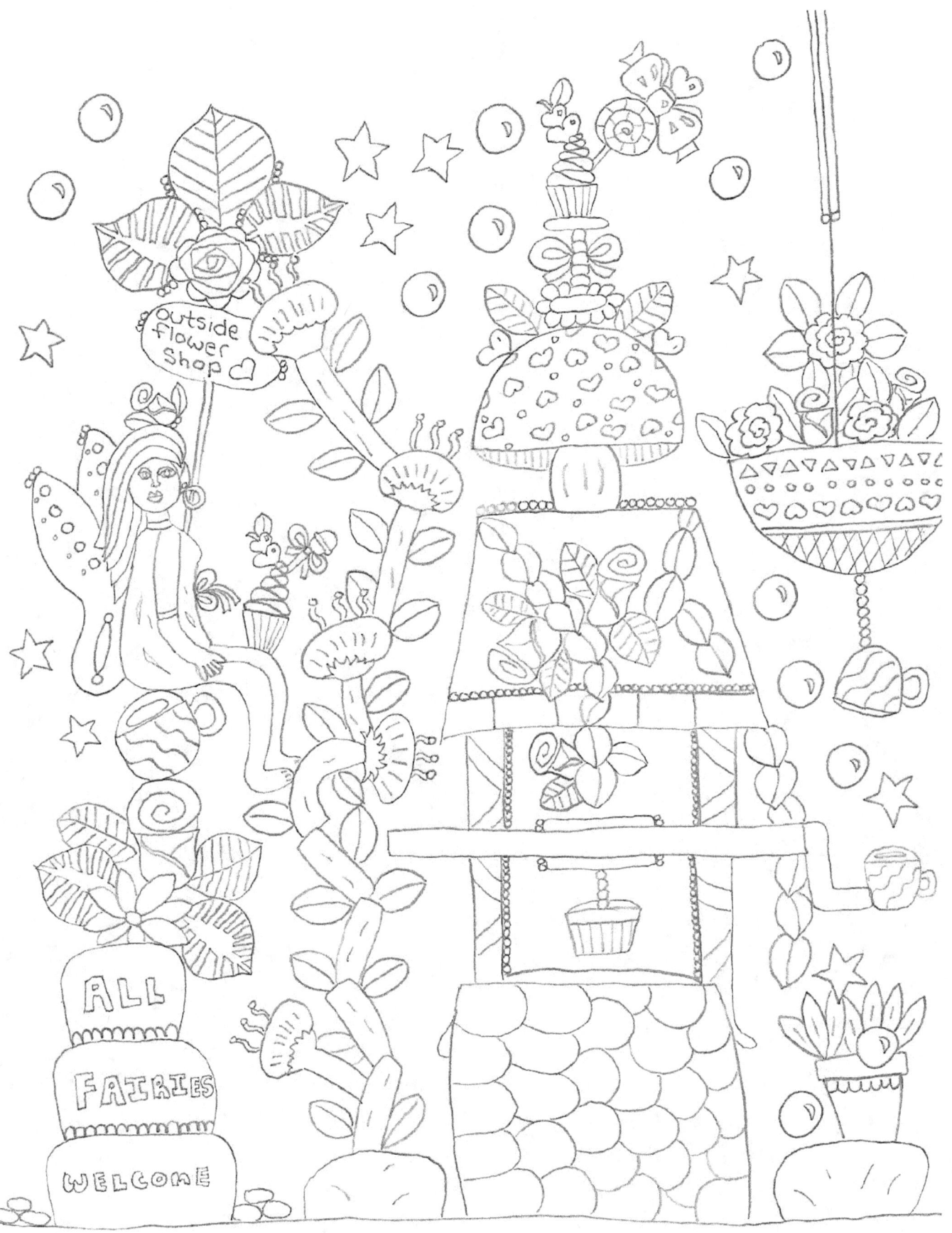

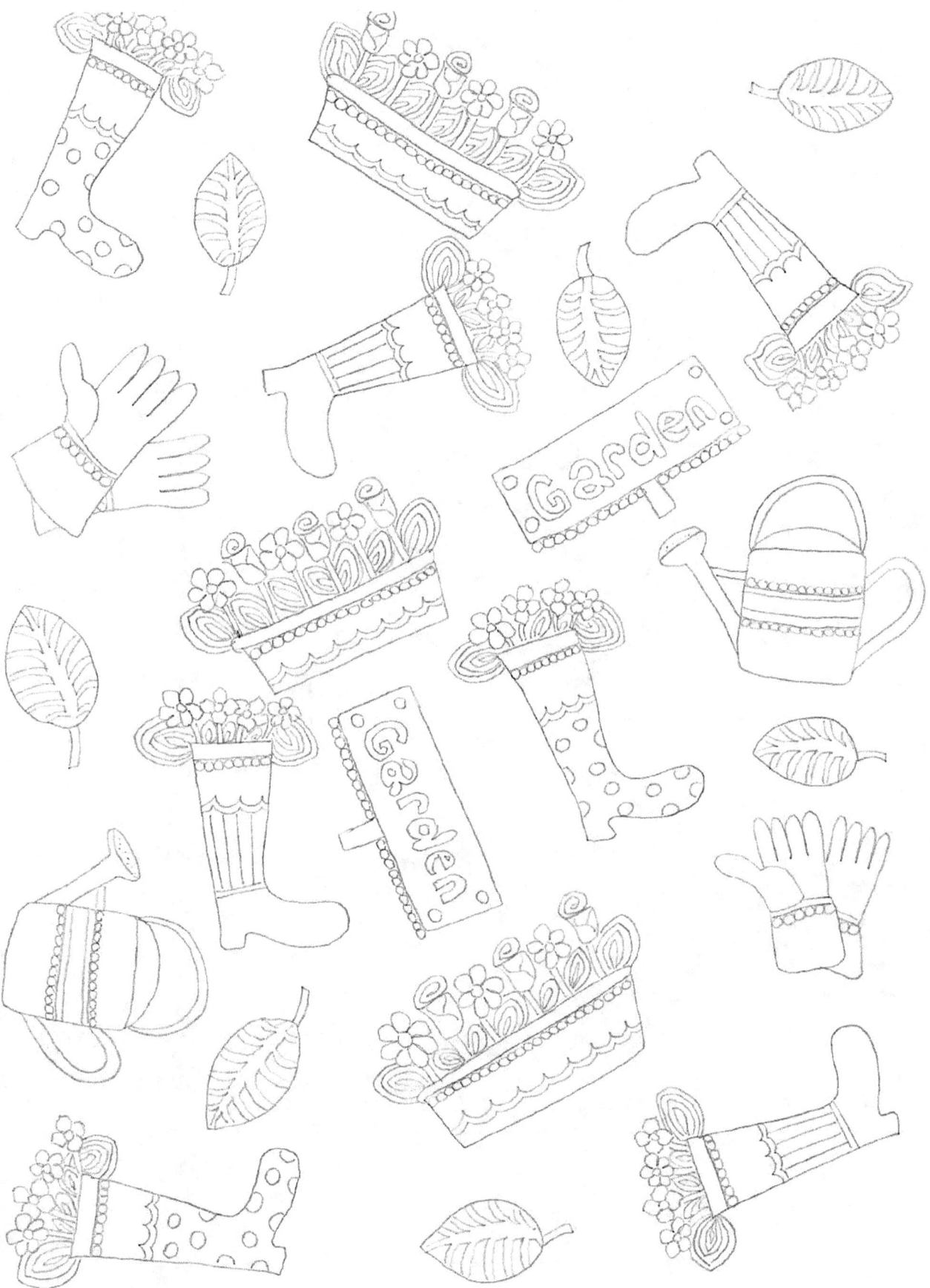

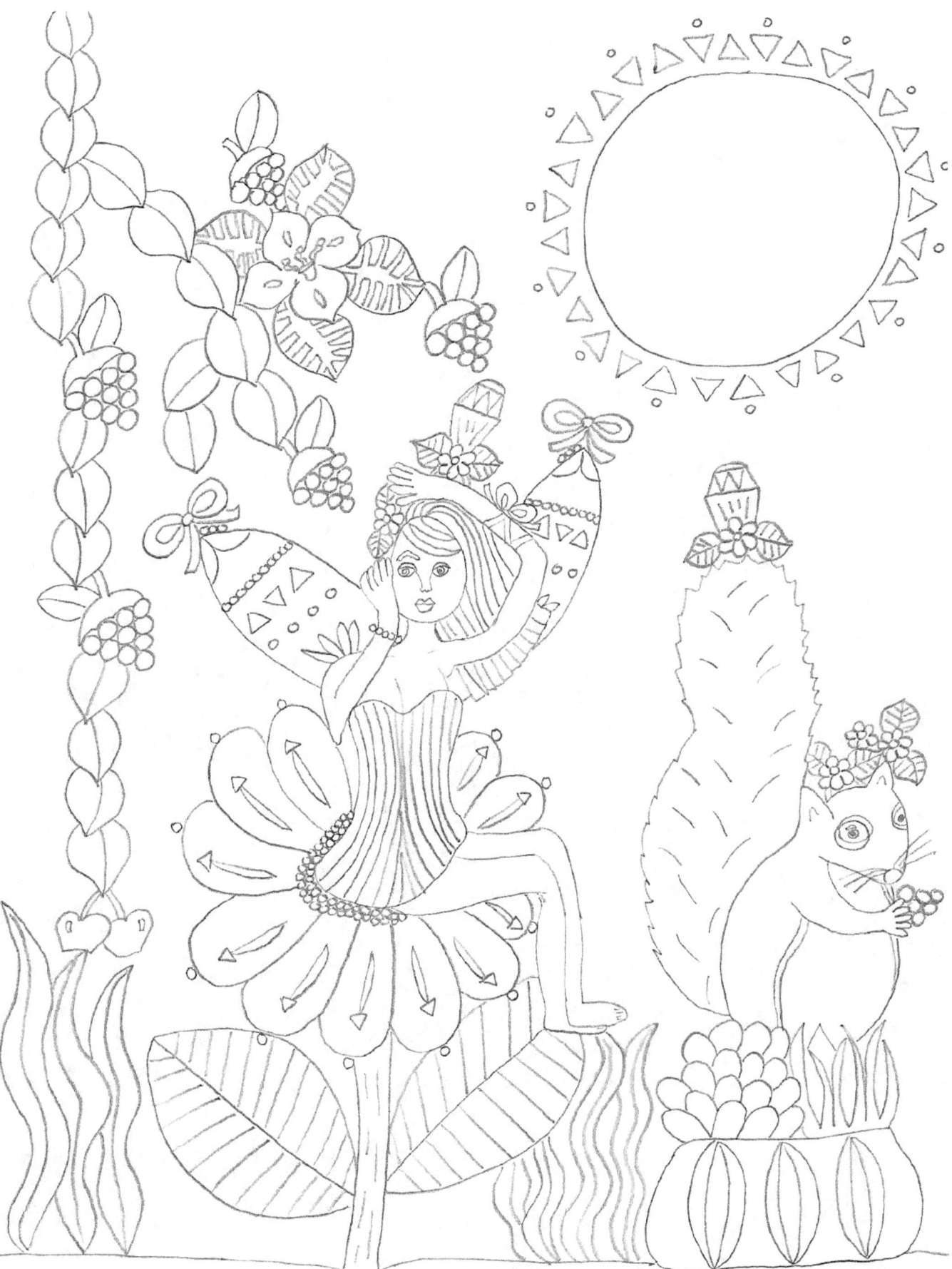

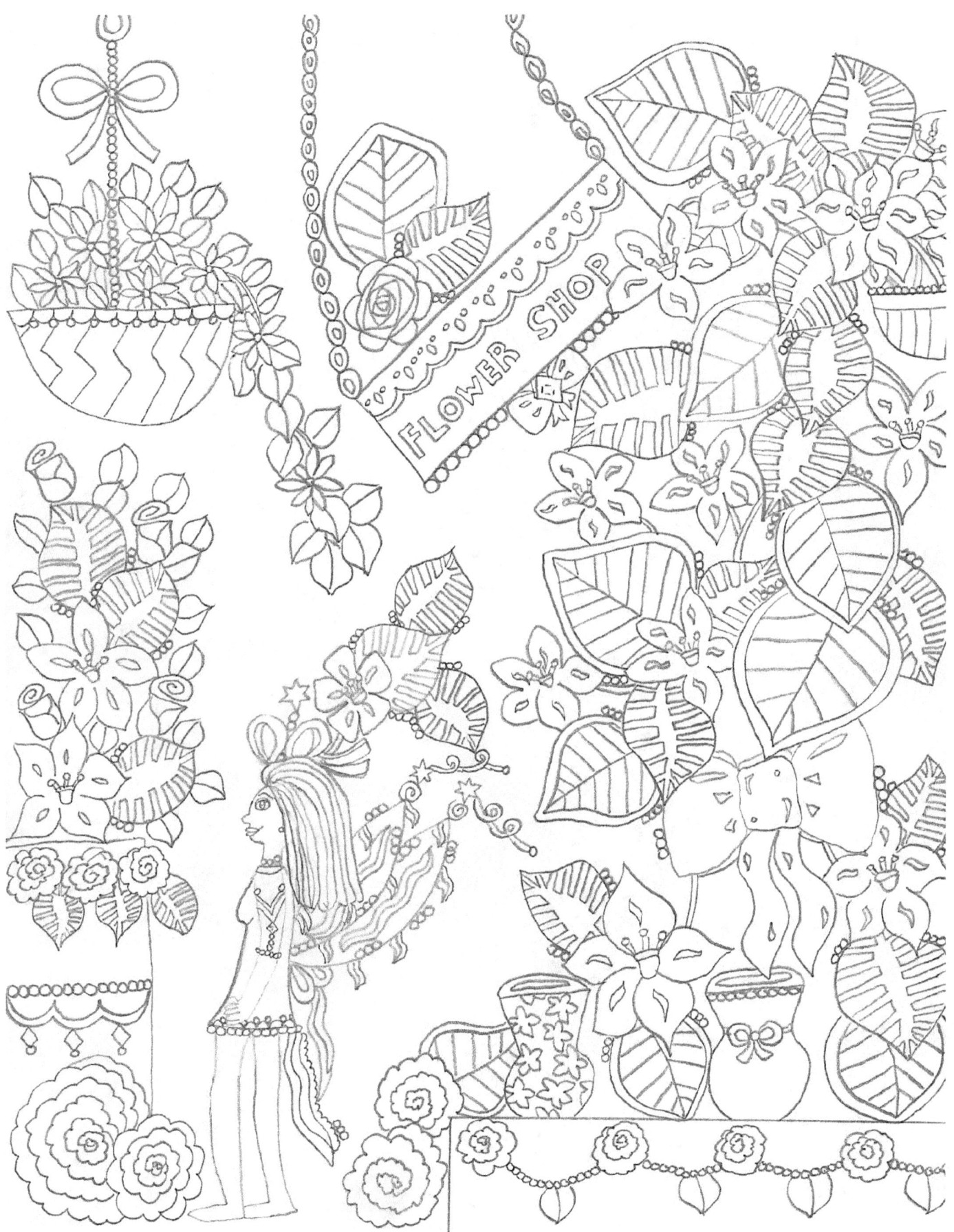

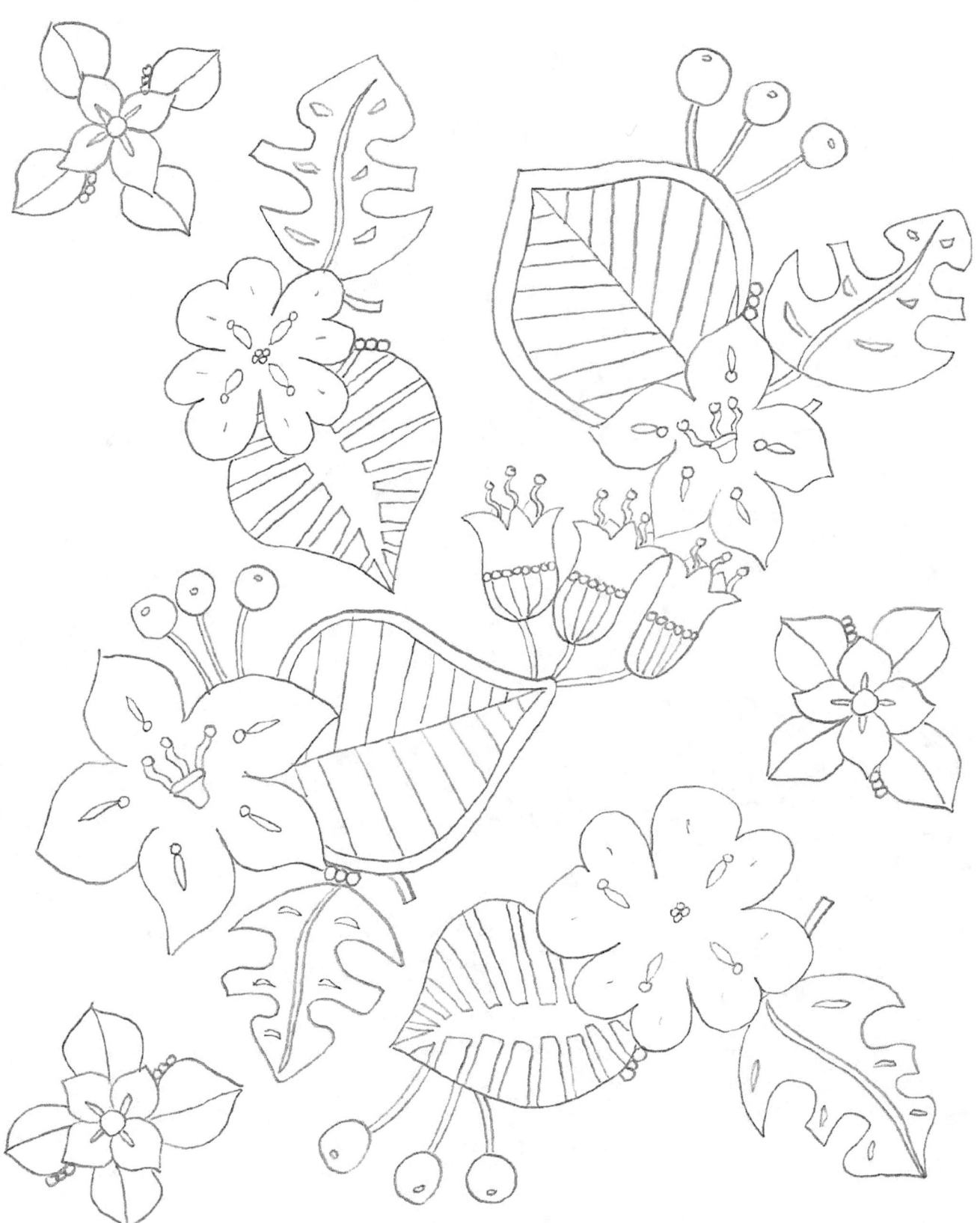

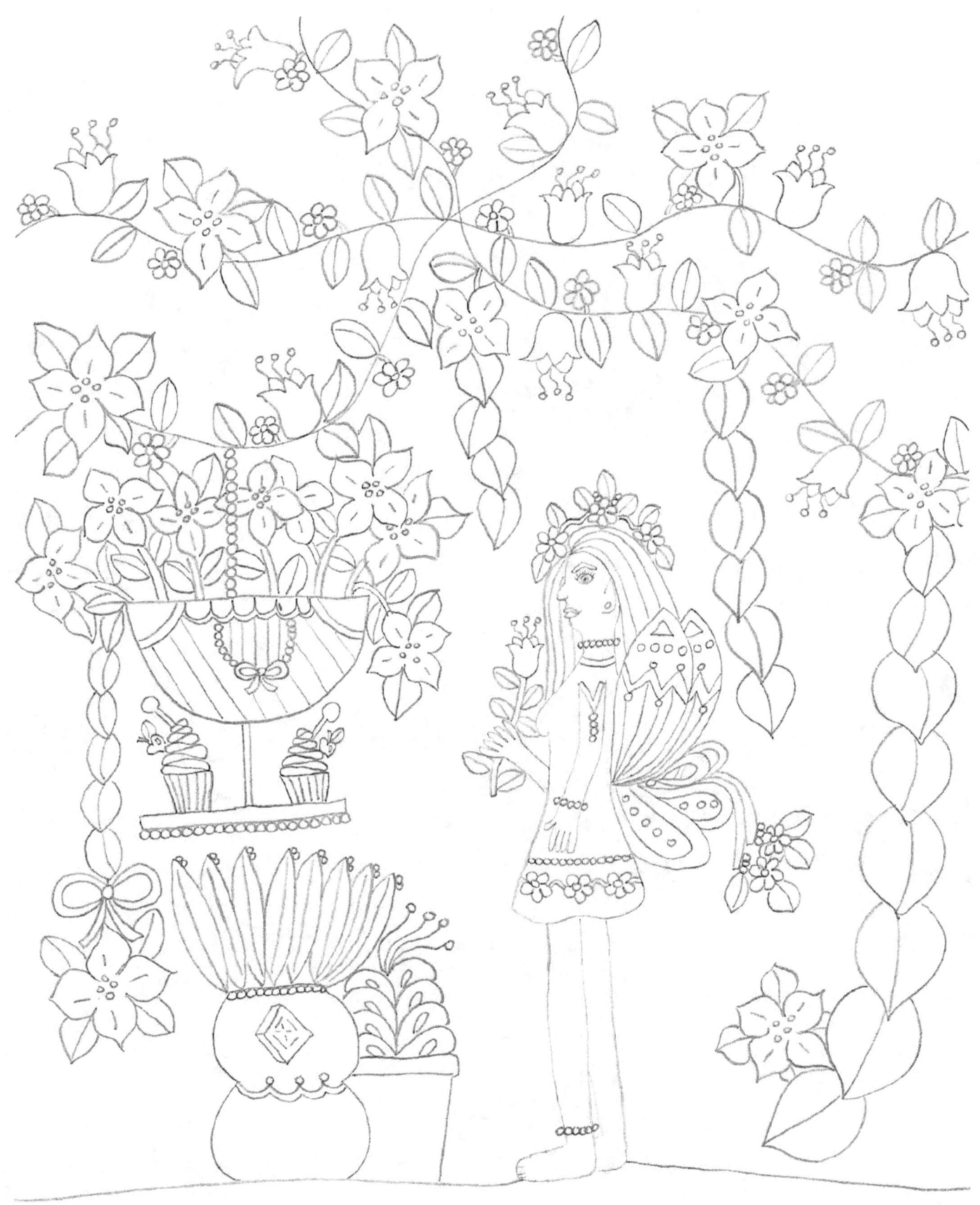

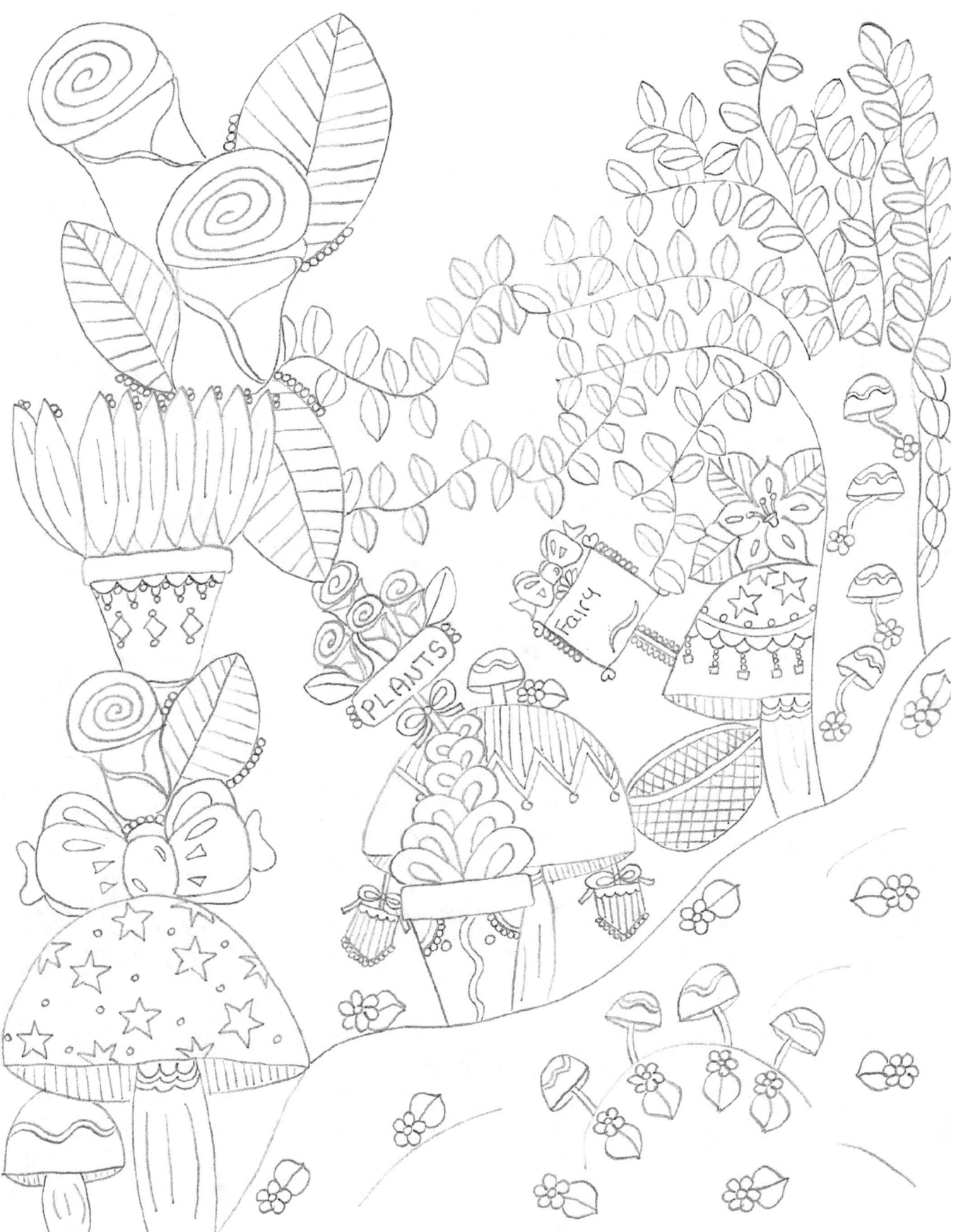

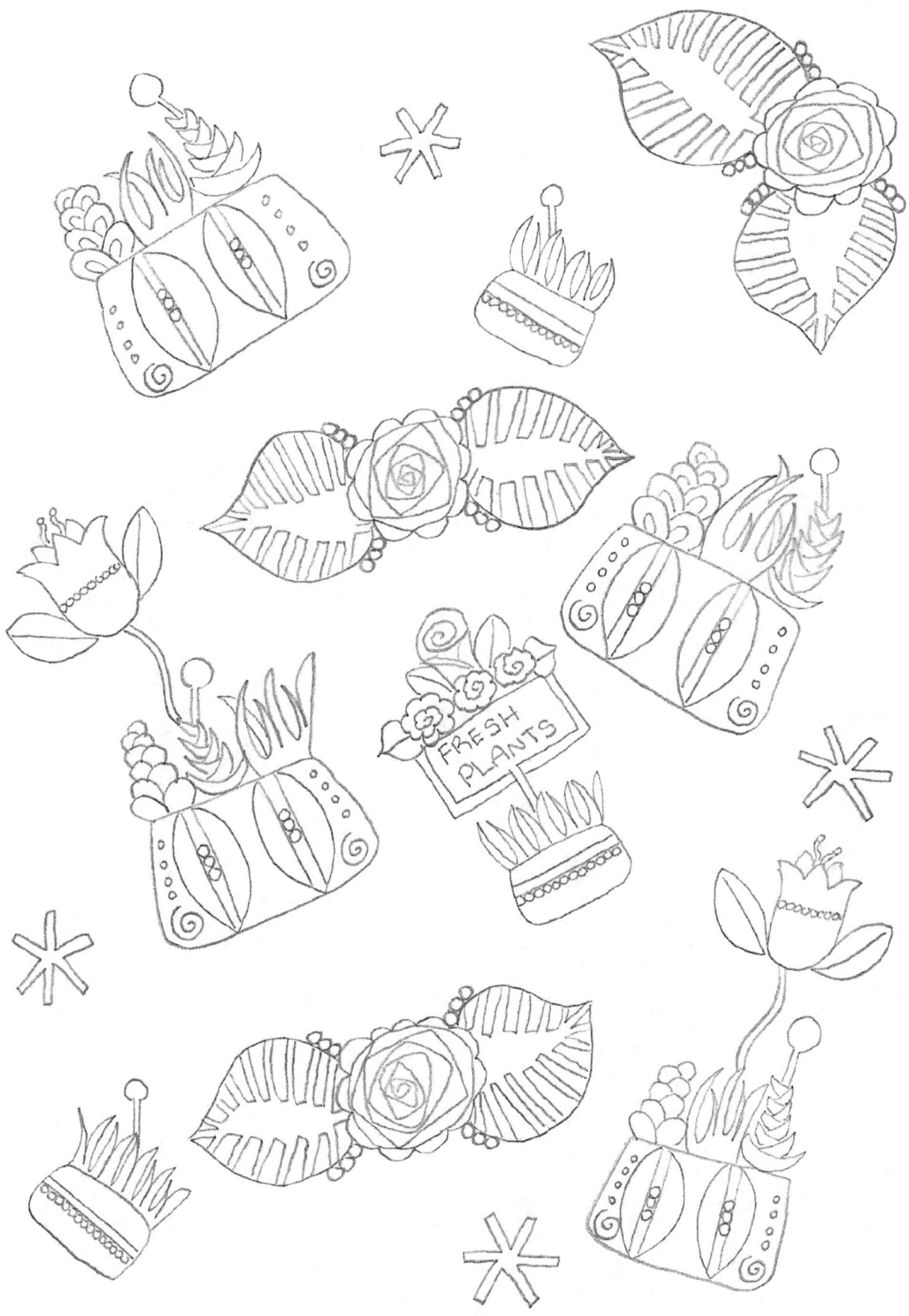

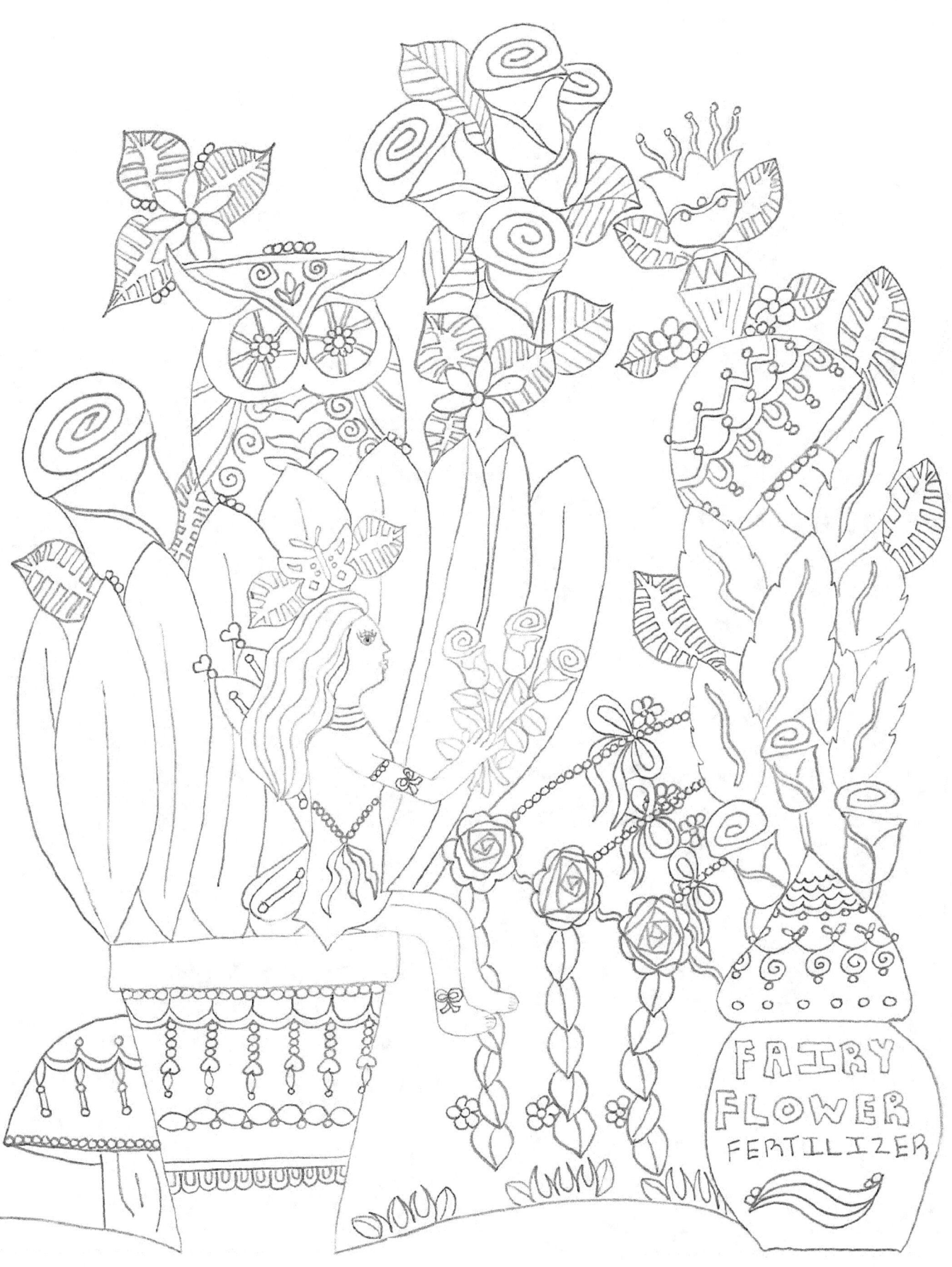

THANK YOU FOR PURCHASING FAIRIES IN THE FLOWER SHOP. IF YOU ENJOYED YOUR COLORING EXPERIENCE, PLEASE CHECK OUT THESE OTHER BOOKS BY ME AT AMAZON.COM:

VINTAGE WINE GARDEN

VINTAGE PARIS BAKE SHOP

ICE CREAM MADNESS

ICE CREAM MADNESS VOLUME 2

TEA & COFFEE TROPICAL TREASURES

TEA & COFFEE OCEAN TREASURES

TEA & COFFEE TREASURES

BOTANICAL FLOWERS & MANDALAS

MAJESTIC FALL

A VERY RETRO CHRISTMAS

MERMAIDS' WONDERLAND SEA OF ENCHANTMENT

A SPECIAL THANK YOU TO MY FRIEND, MARY ENGLES, WHO COLORED THE FRONT COVER.

IF YOU ENJOYED YOUR COLORING EXPERIENCE, PLEASE TELL OTHERS ABOUT IT BY WRITING A REVIEW ON AMAZON.COM UNDER THE BOOK YOU COLORED.

www.ingramcontent.com/pod-product-compliance
Lightning Source LLC
Chambersburg PA
CBHW081619220526
45468CB00010B/2952